NORTHWEST COAST
INDIAN DESIGNS

Madeleine Orban-Szontagh

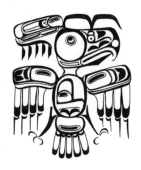

DOVER PUBLICATIONS, INC.
New York

PUBLISHER'S NOTE

The Indian peoples of the Northwest Pacific Coast inhabit a region stretching from Northern California to Alaska. Their cultures are extremely complex, varying in their social structure, economy and religion. It is for their arts and crafts, however, that these groups are most famous. Since the region the Indians inhabit is heavily forested, wood is the major medium in which they have executed ritual objects, such as masks and totem poles, as well as objects for daily use. Textiles and pottery are equally fine. Motifs are drawn from family crests and religious and totemic figures. For this anthology, Madeleine Orban-Szontagh has accurately rendered motifs from various media. The names in the captions are generally those of tribes.

COPYRIGHT

Copyright © 1994 by Dover Publications, Inc.
All rights reserved under Pan American and International Copyright Conventions.

Published in Canada by General Publishing Company, Ltd., 30 Lesmill Road, Don Mills, Toronto, Ontario.
Published in the United Kingdom by Constable and Company, Ltd., 3 The Lanchesters, 162–164 Fulham Palace Road, London W6 9ER.

BIBLIOGRAPHICAL NOTE

Northwest Coast Indian Designs is a new work, first published by Dover Publications, Inc., in 1994.

DOVER *Pictorial Archive* SERIES

This book belongs to the Dover Pictorial Archive Series. You may use the designs and illustrations for graphics and crafts applications, free and without special permission, provided that you include no more than four in the same publication or project. (For permission for additional use, please write to: Permissions Department, Dover Publications, Inc., 180 Varick Street, New York, N.Y. 10014.)
However, republication or reproduction of any illustration by any other graphic service, whether it be in a book or in any other design resource, is strictly prohibited.

LIBRARY OF CONGRESS CATALOGING-IN-PUBLICATION DATA

Orban-Szontagh, Madeleine.
 Northwest Coast Indian designs / Madeleine Orban-Szontagh.
 p. cm. — (Dover design library) (Dover pictorial archive series)
 ISBN 0-486-28179-5 (pbk.)
 1. Indian art—Northwest Coast of North America—Themes, motives. 2. Indian baskets—Northwest Coast of North America. 3. Indian textile fabrics—Northwest Coast of North America. 4. Textile design—Northwest Coast of North America. I. Title. II. Series. III. Series: Dover pictorial archive series.
E78.N78073 1994
745.4'089'972—dc20 94-19490
 CIP

Manufactured in the United States of America
Dover Publications, Inc., 31 East 2nd Street, Mineola, N.Y. 11501

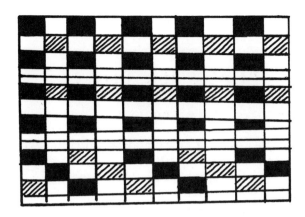

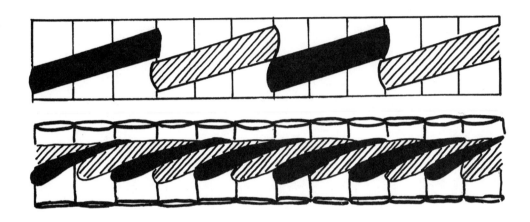

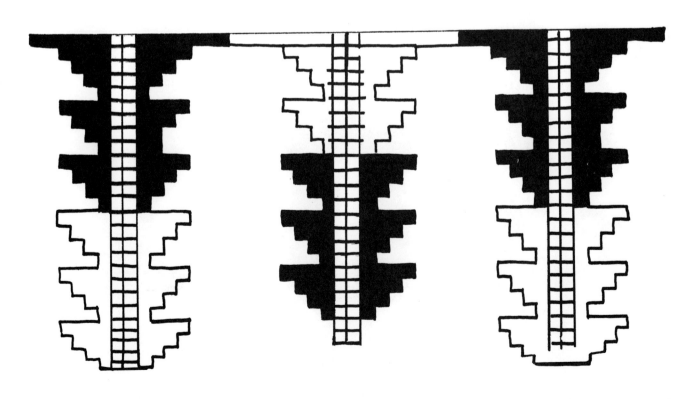

Cowichan basket designs

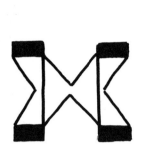 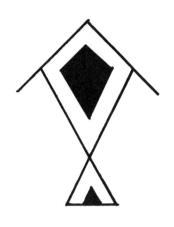 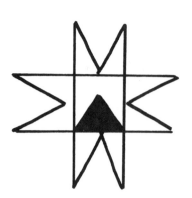

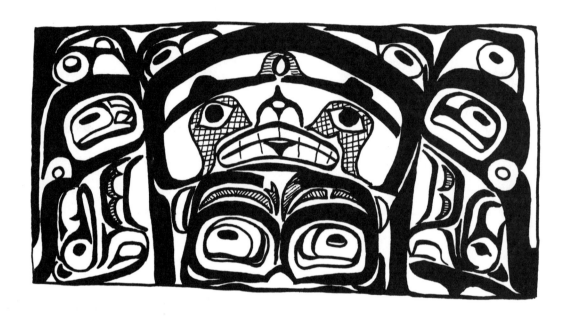

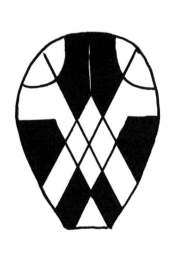 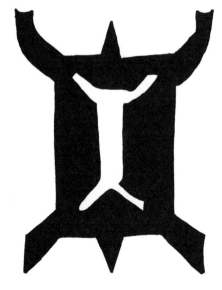 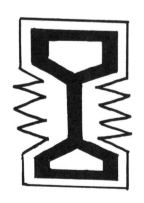

Haida

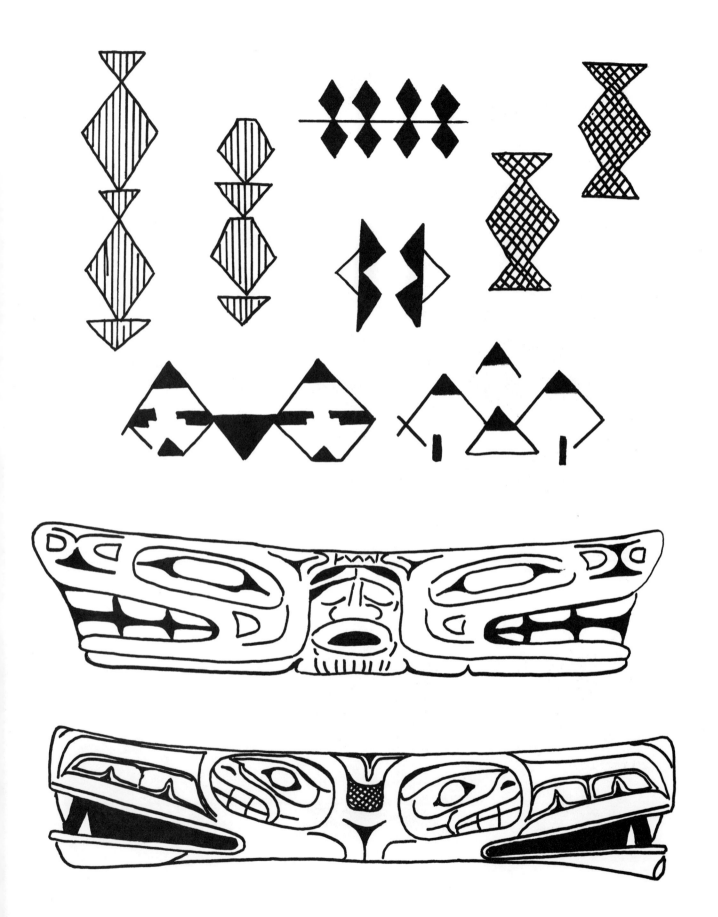

Tlingit

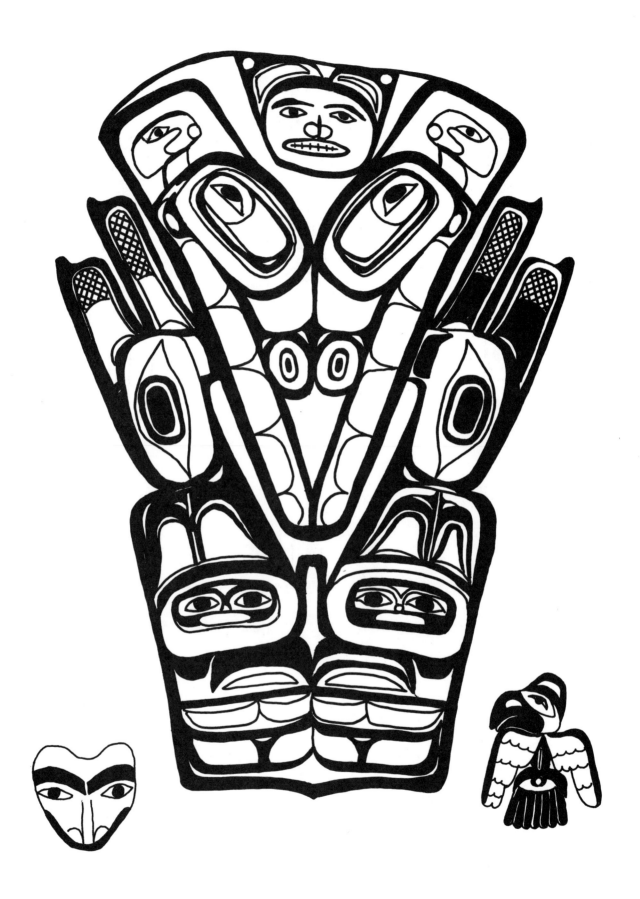

Tlingit

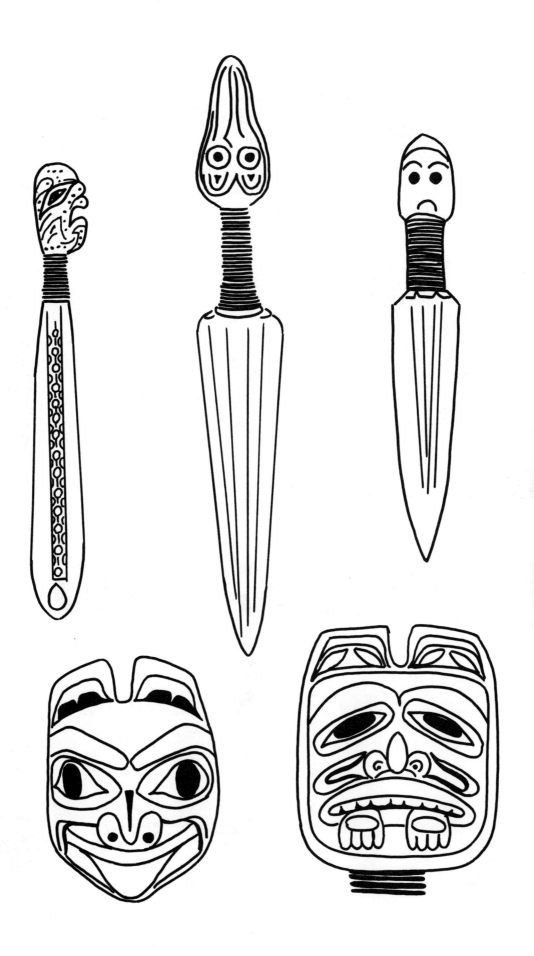

Tlingit

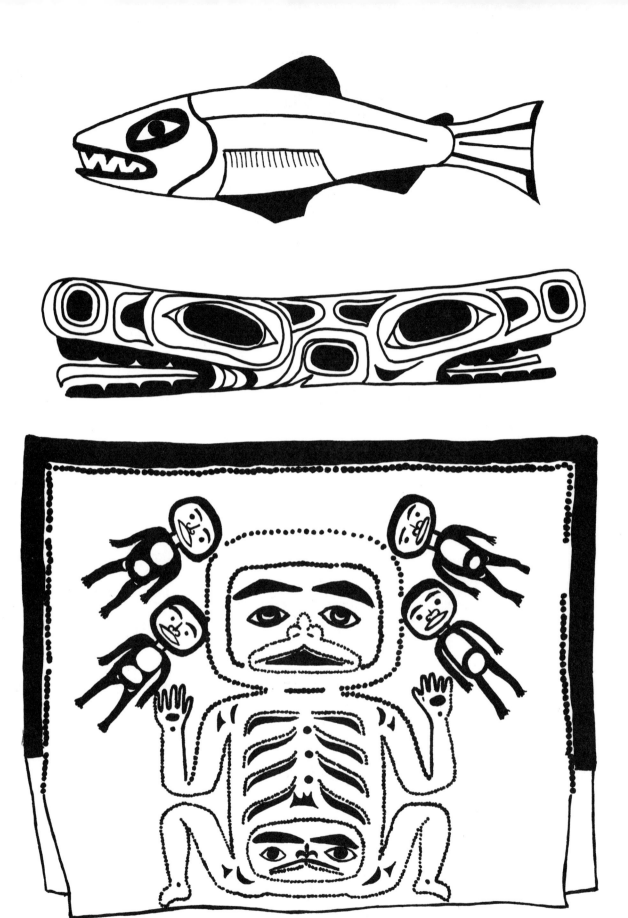

Tlingit and Tsimshian

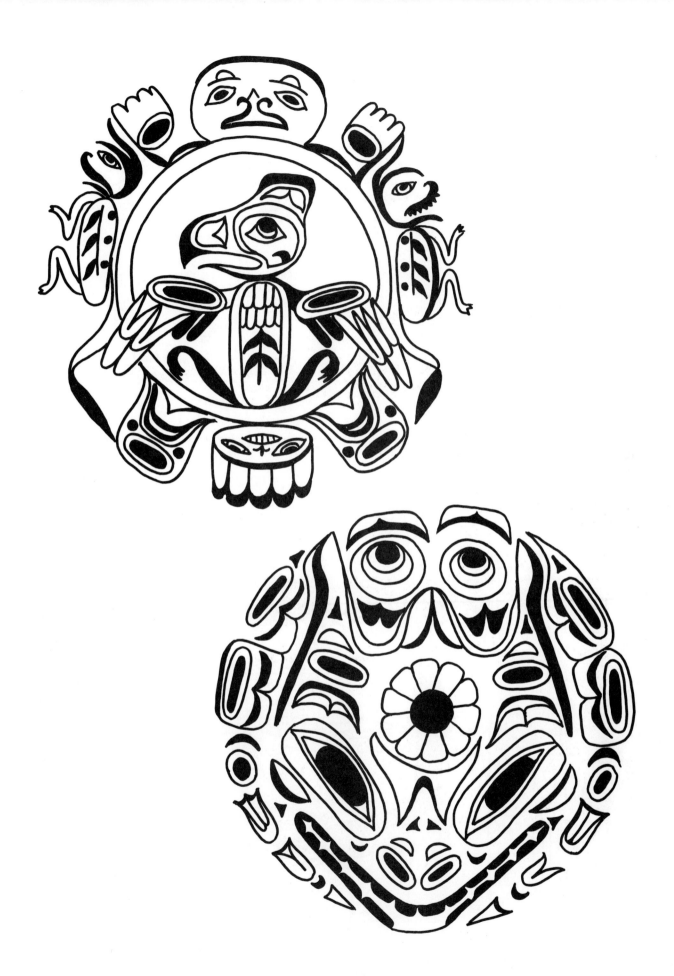

Tsimshian

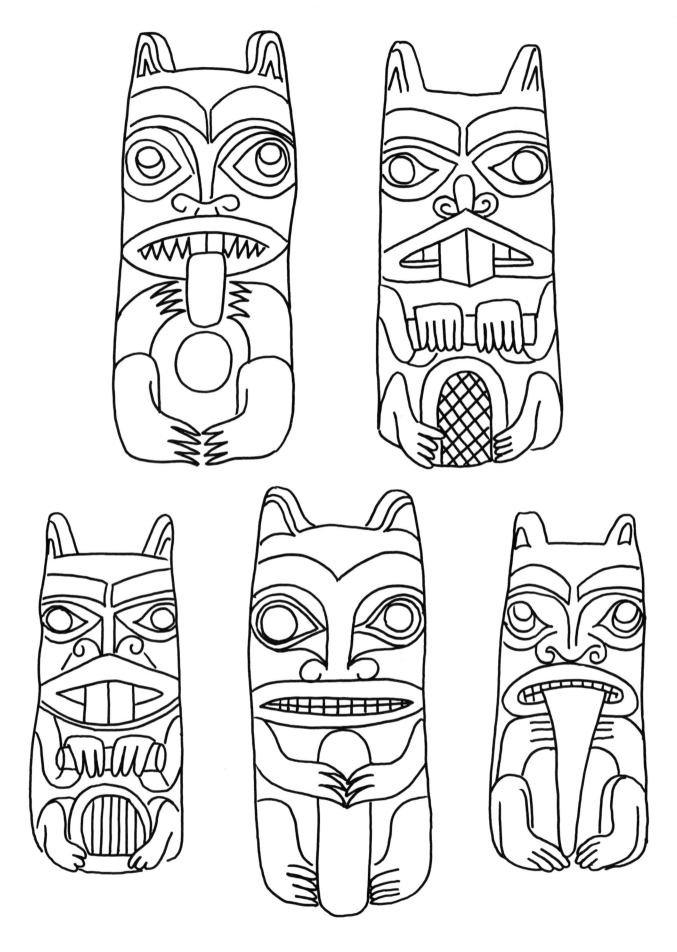

Haida

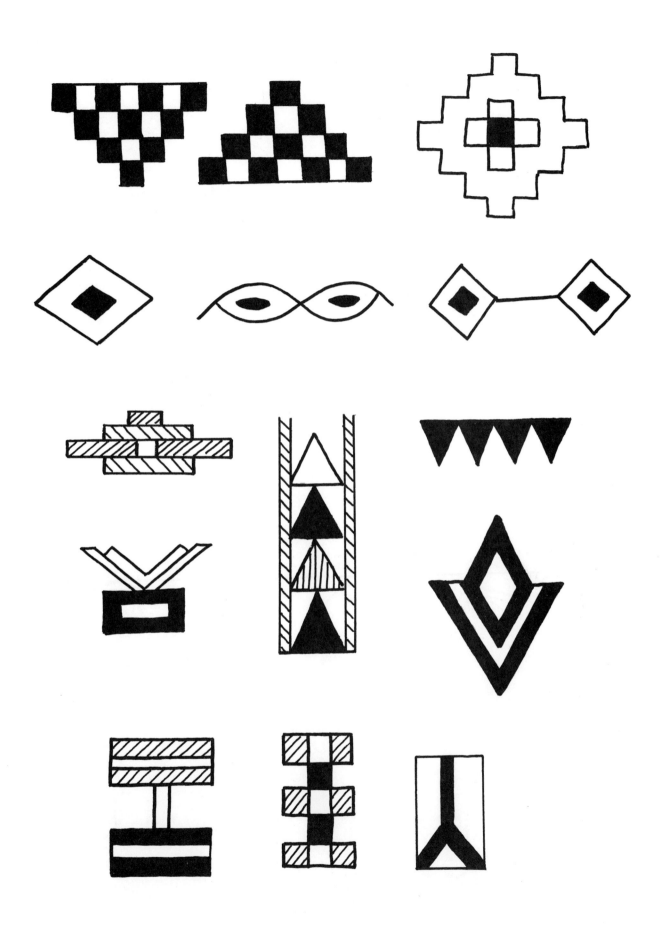

Makah basket designs

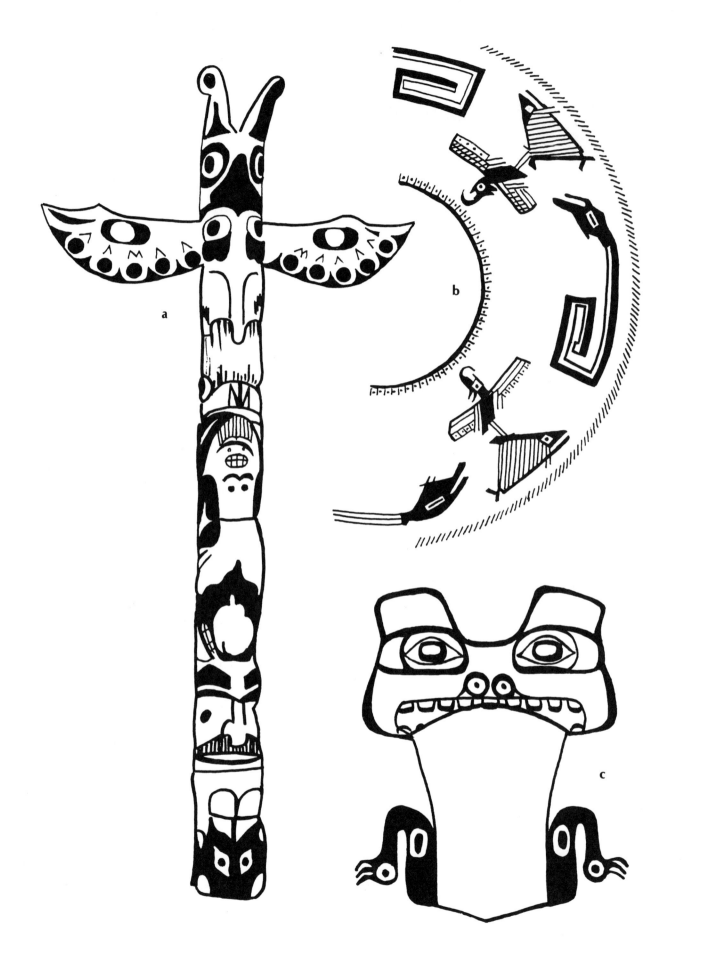

(a) Kwakiutl (b) Vancouver Island (c) Tlingit

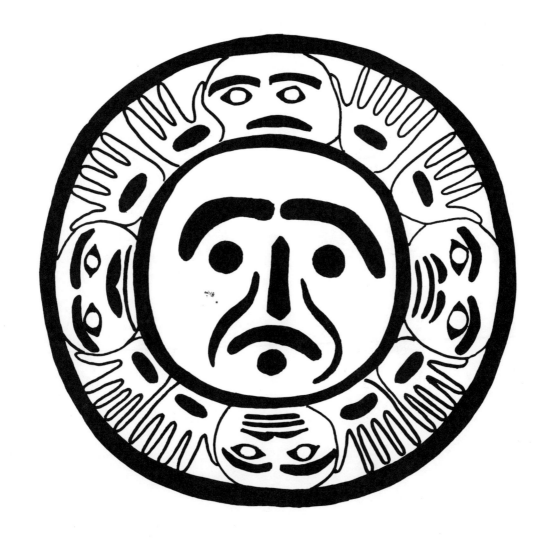

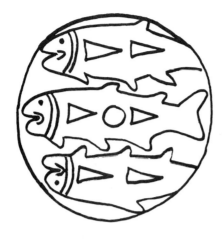
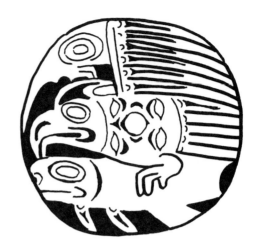
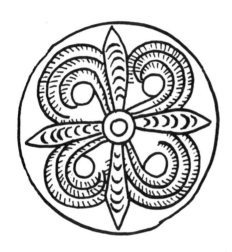
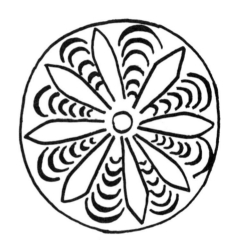
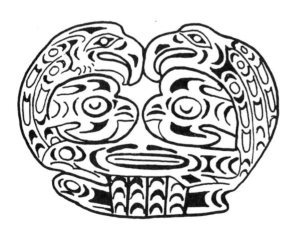
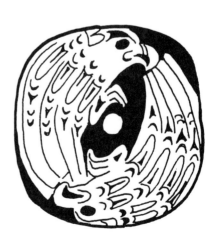

Clallam

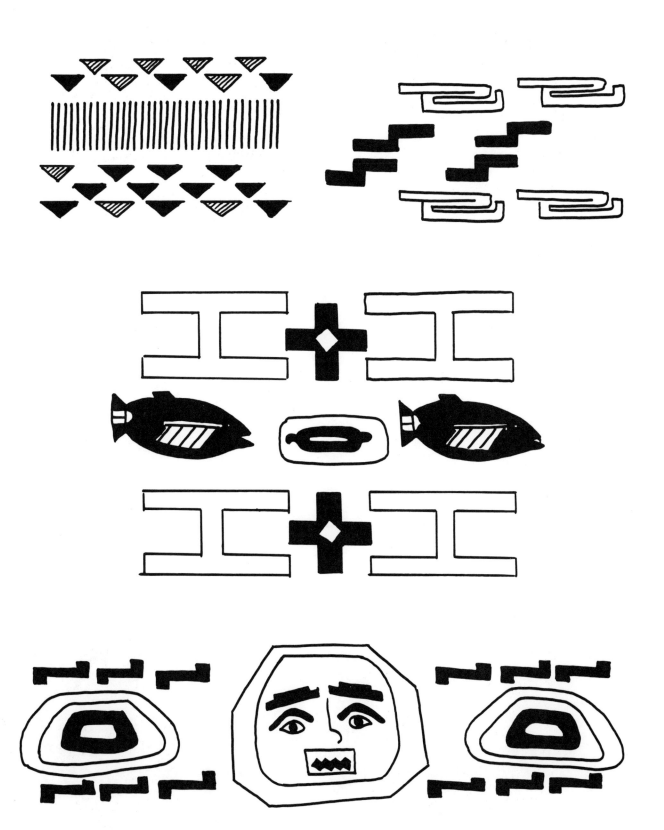

Tlingit basket designs 13

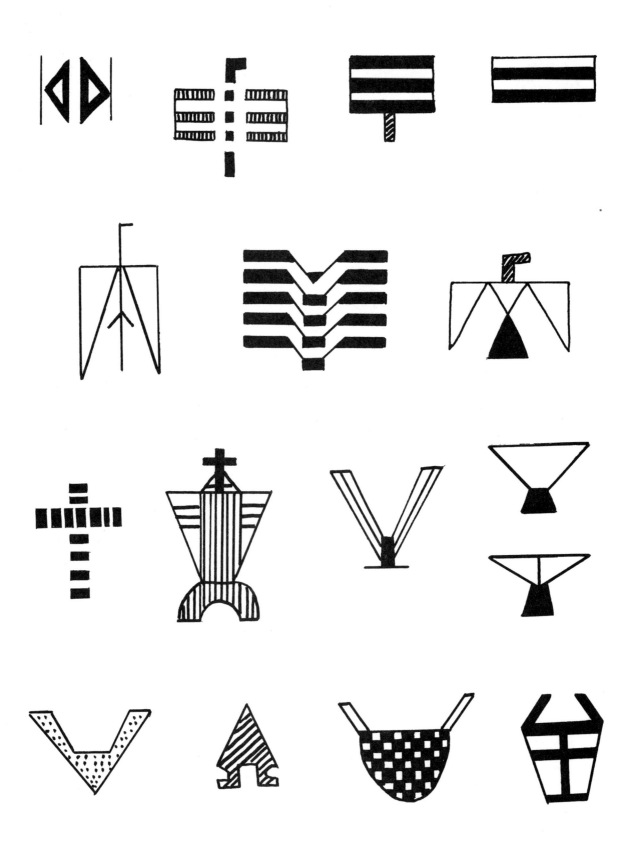

Thompson basket designs

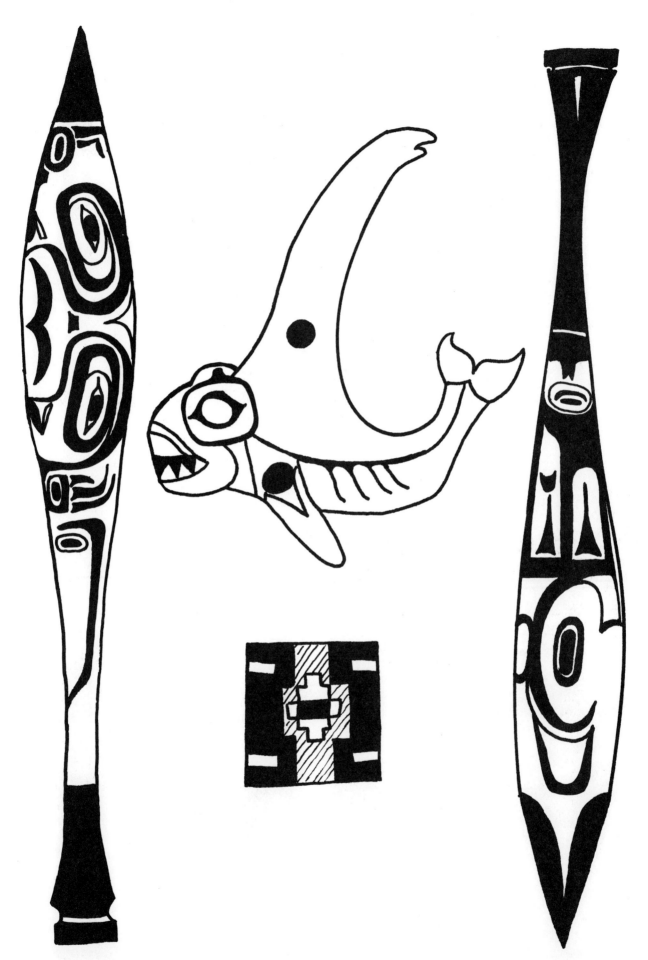

Haida

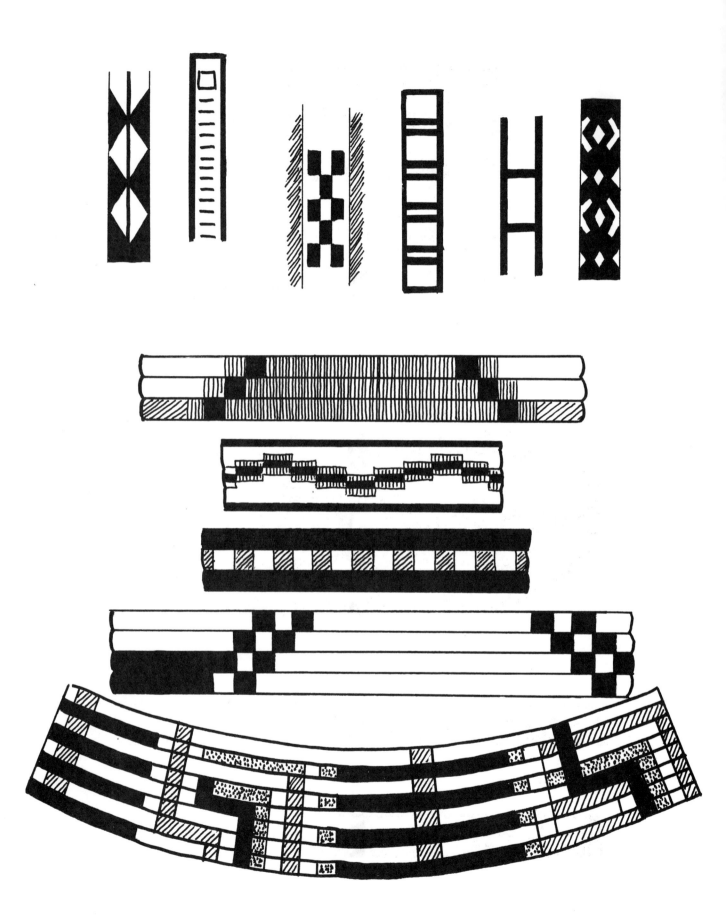

Tlingit basket designs

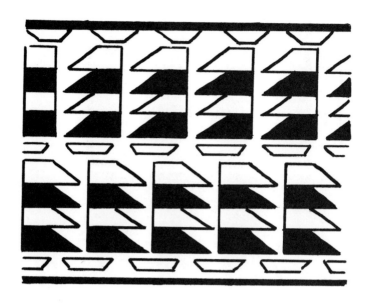

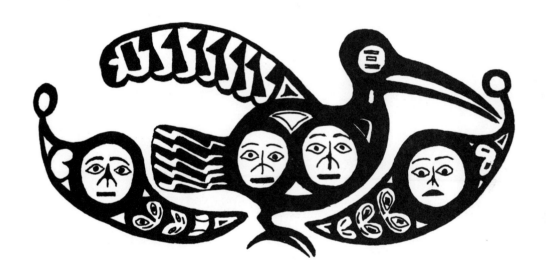

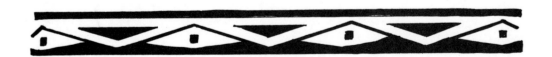

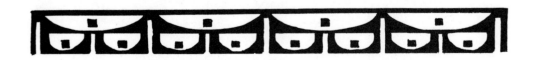

Nootka

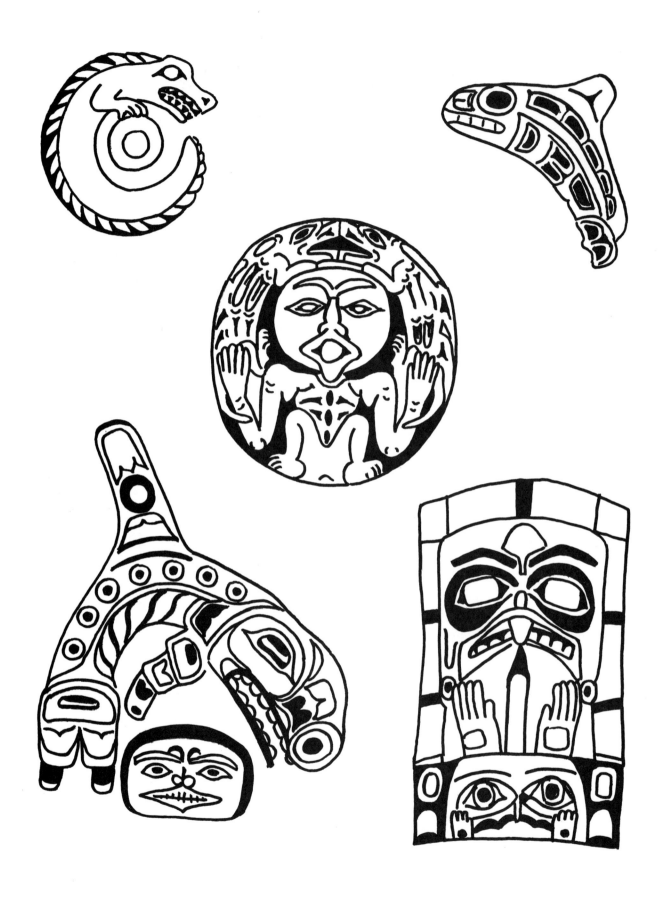

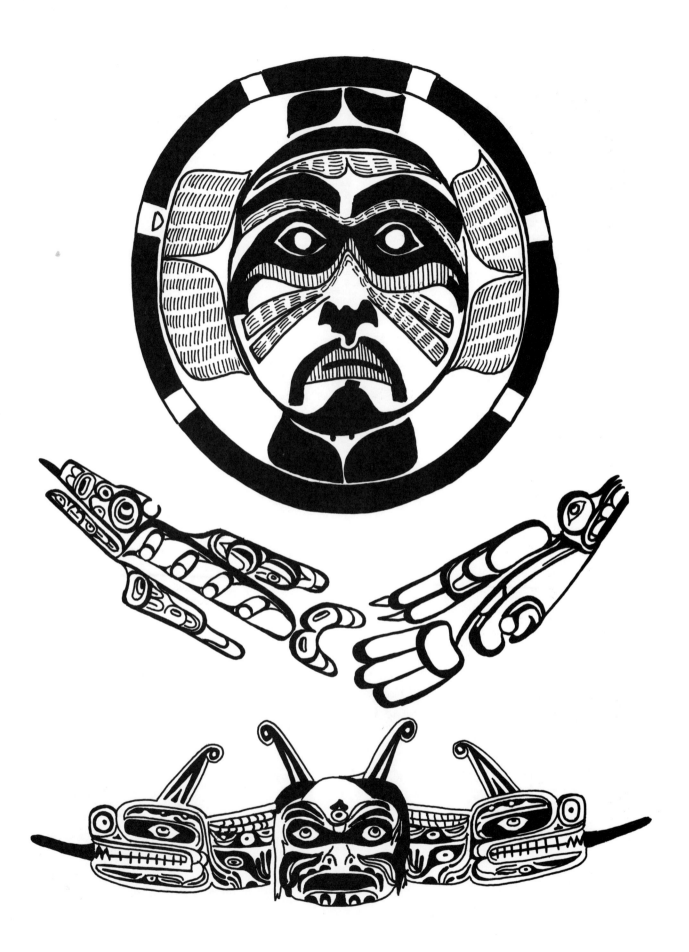

Kwakiutl

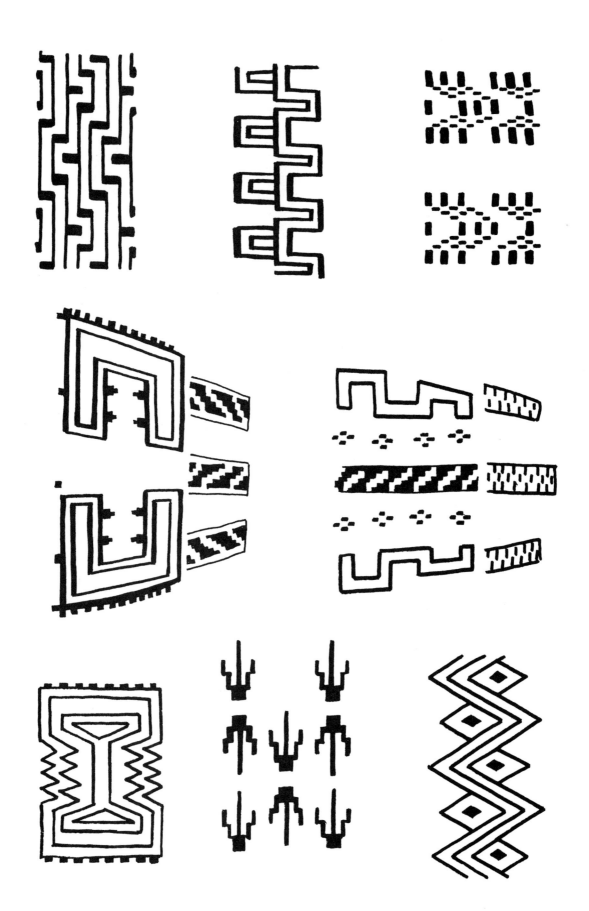

Nootka basket designs

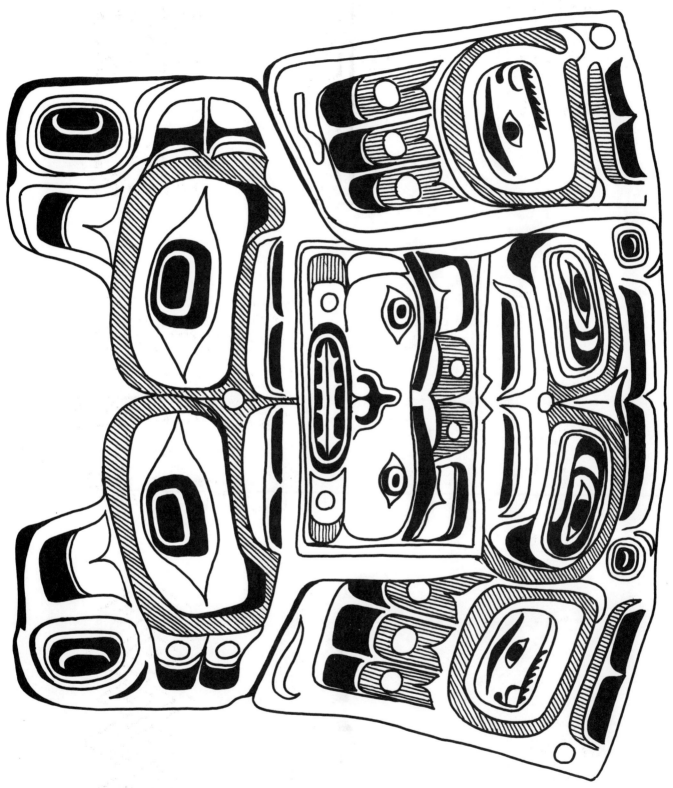

Tlingit

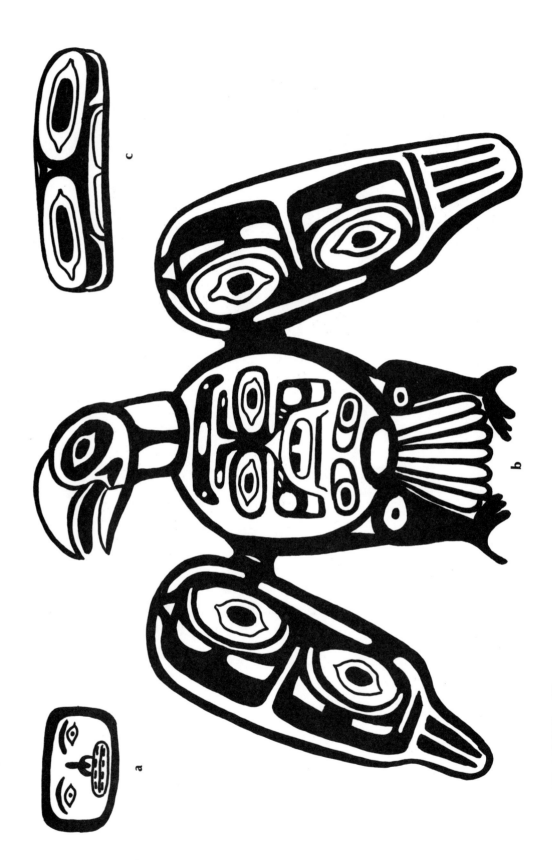

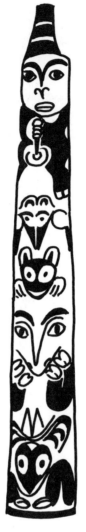

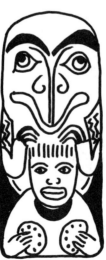

(a–c) Tlingit (d & e) Haida

22

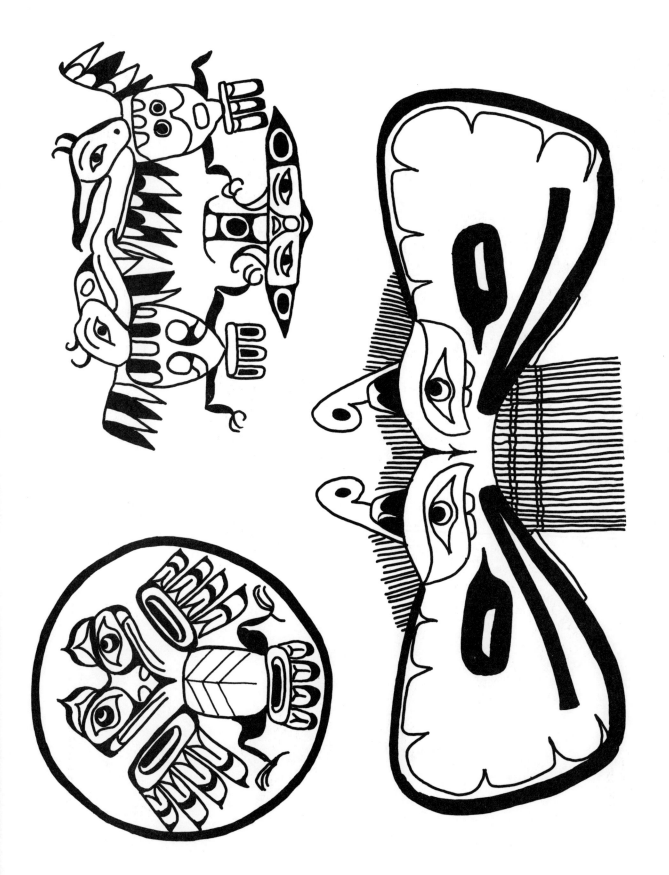

Kwakiutl

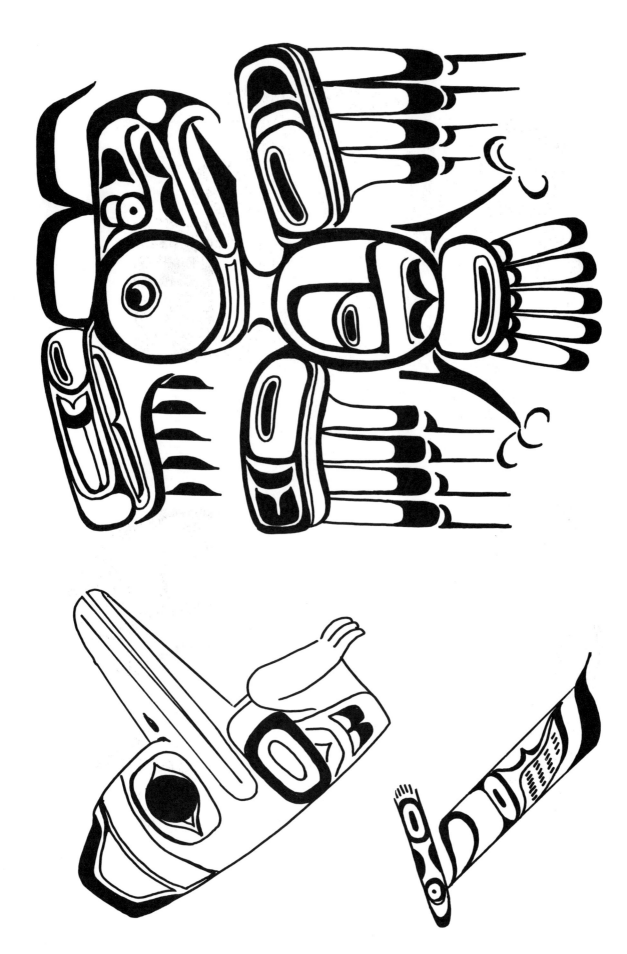

Kwakiutl

24

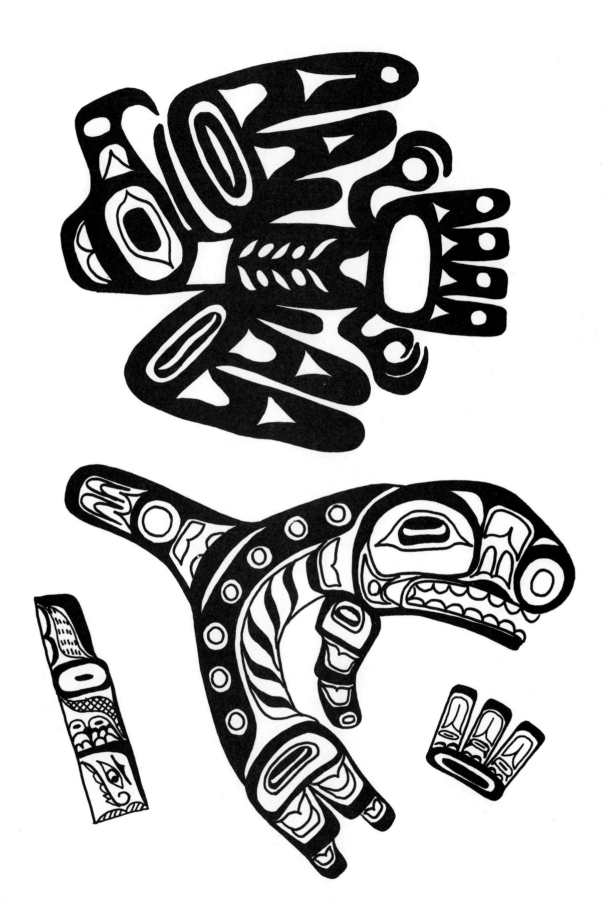

Kwakiutl

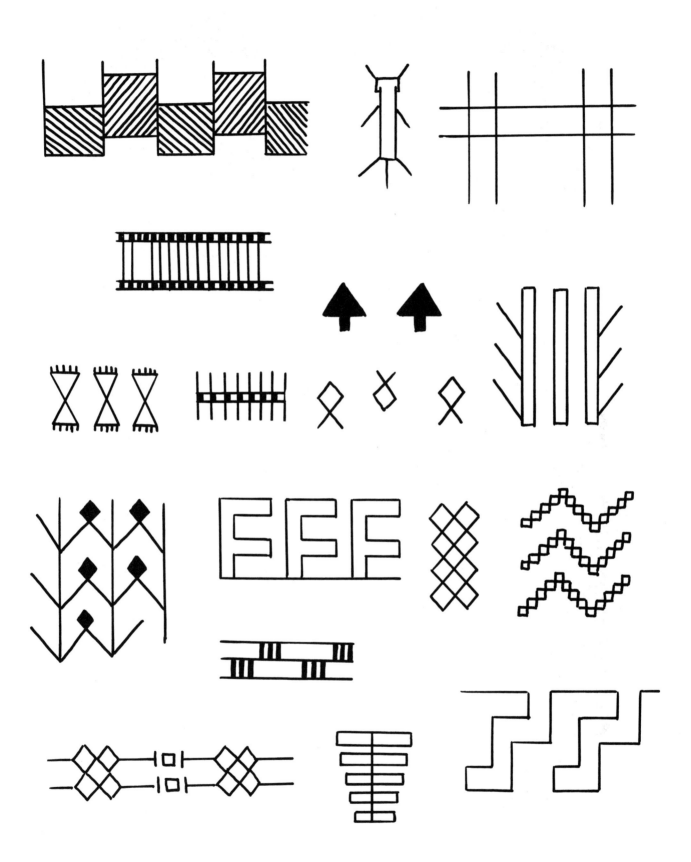

Thompson basket designs

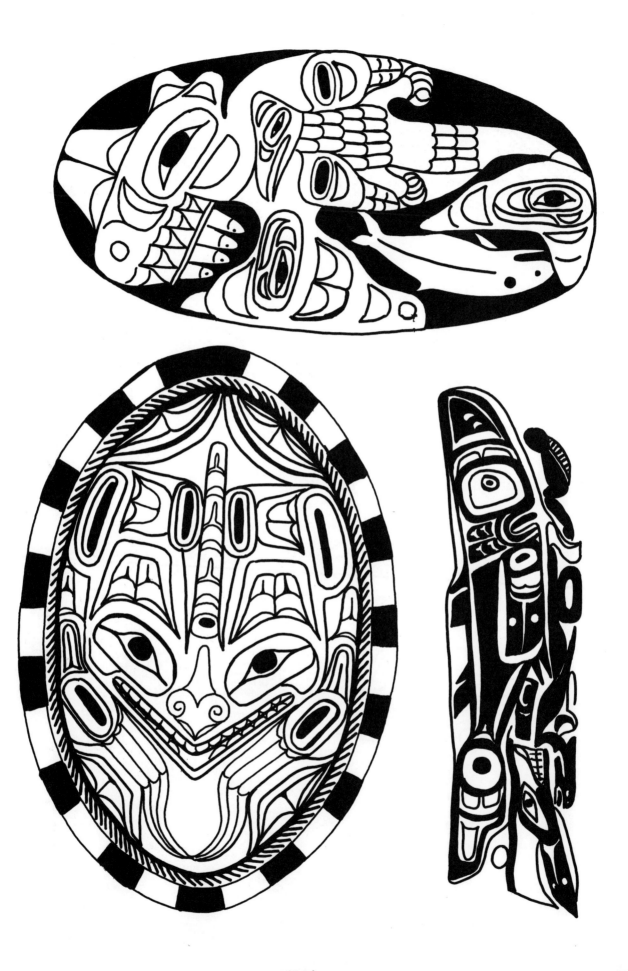

Haida

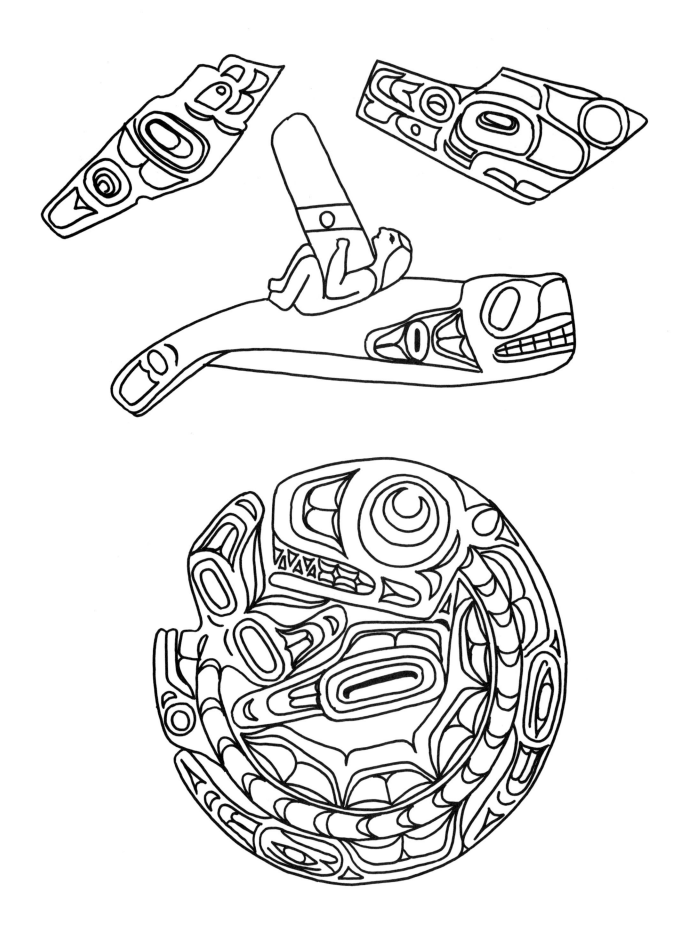

Haida

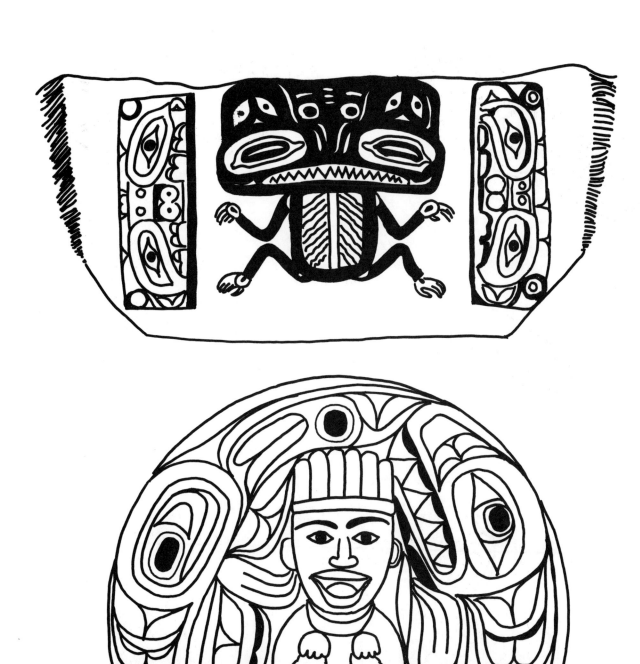

Haida

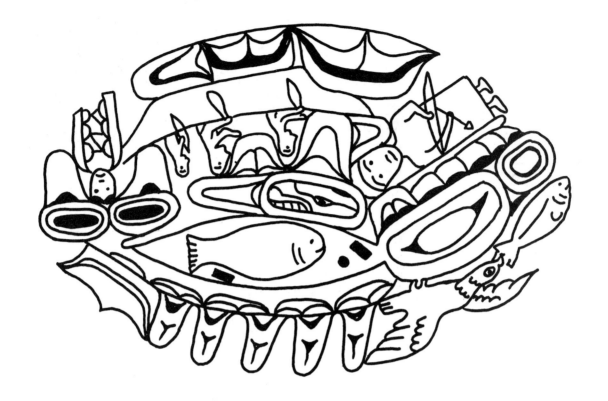

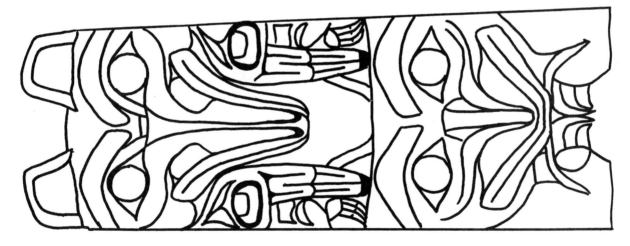

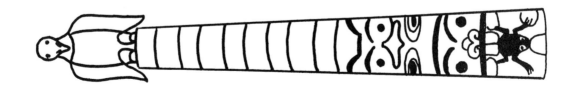

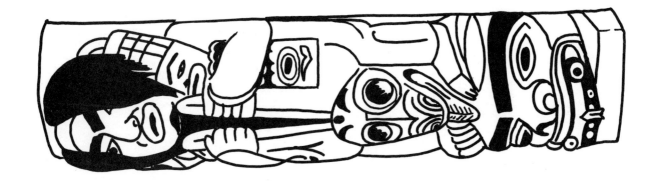

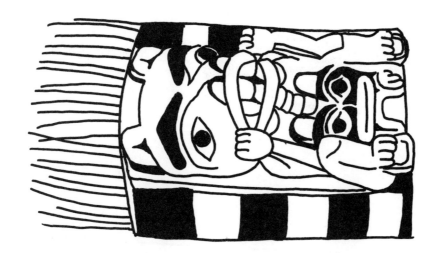

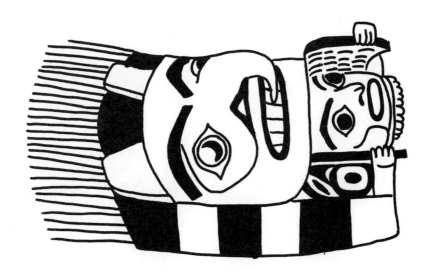

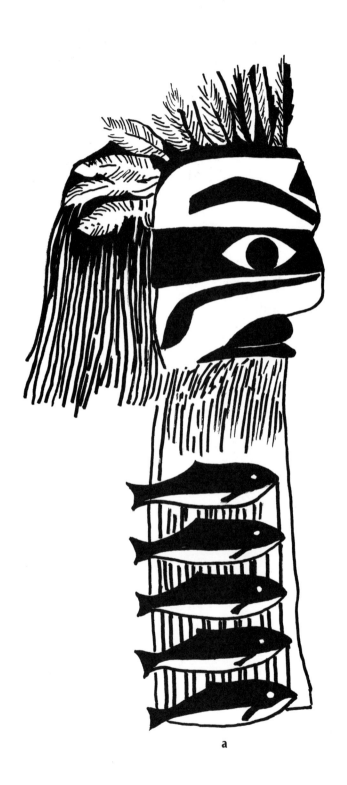

a

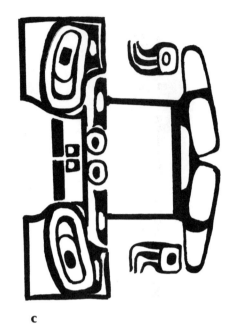

c

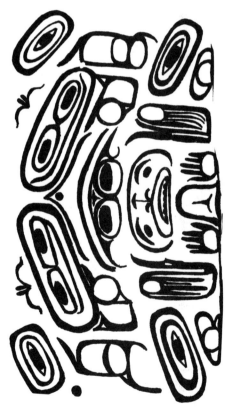

b

(a) Nootka (b & c) Tlingit

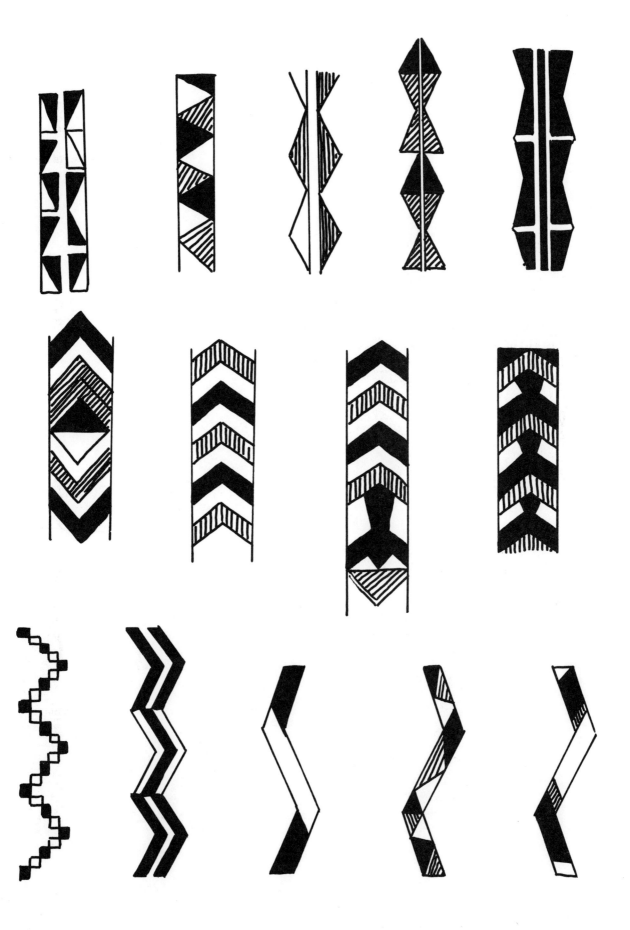

Nootka basket designs

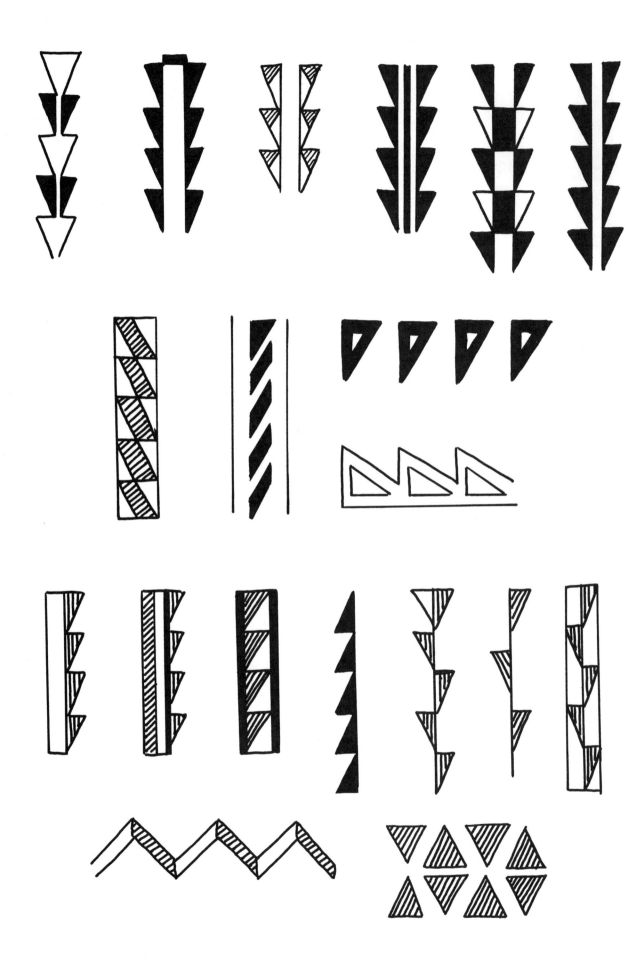

Nootka basket designs

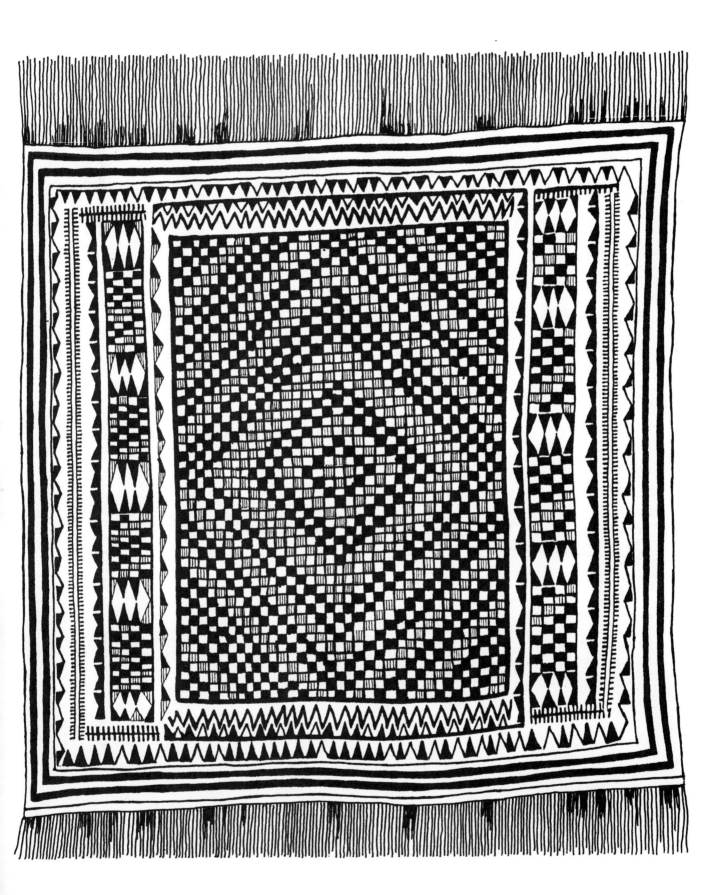

Clallam

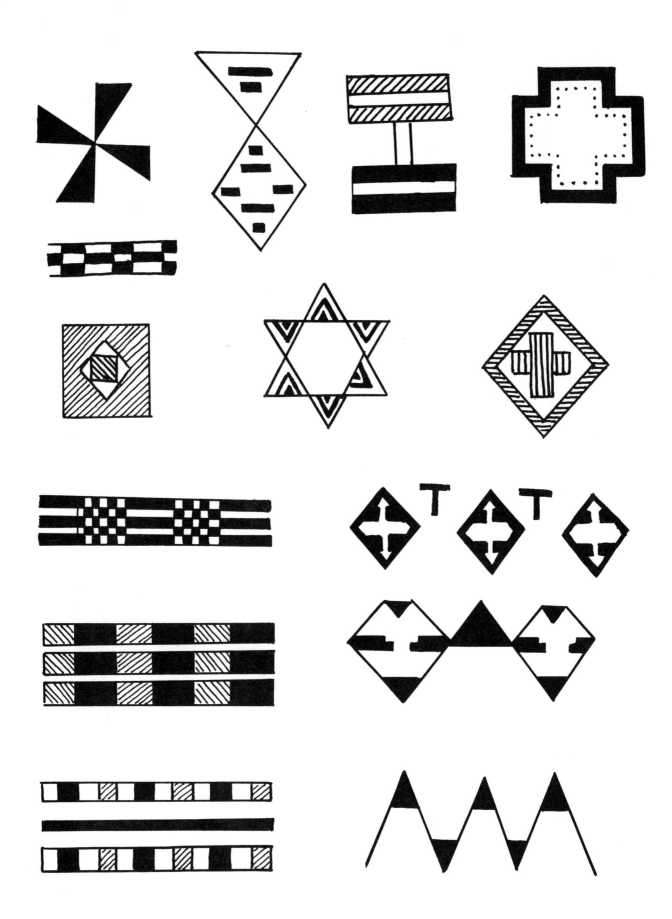

Thompson basket designs

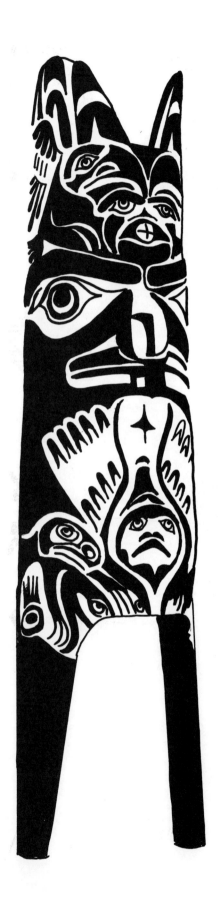

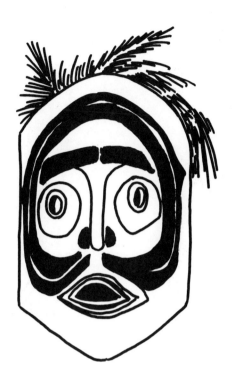

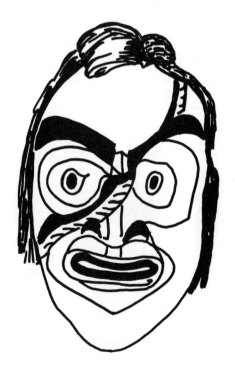

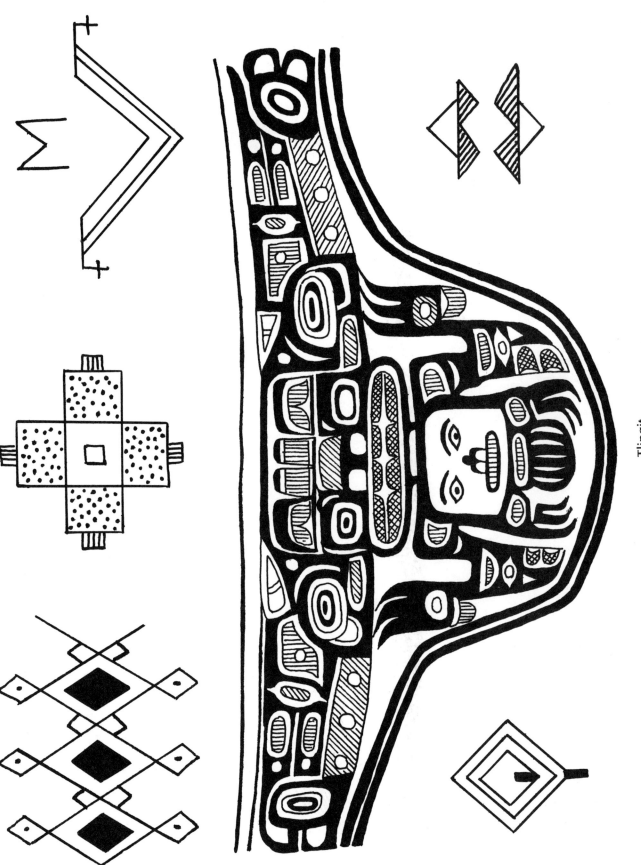

Tlingit

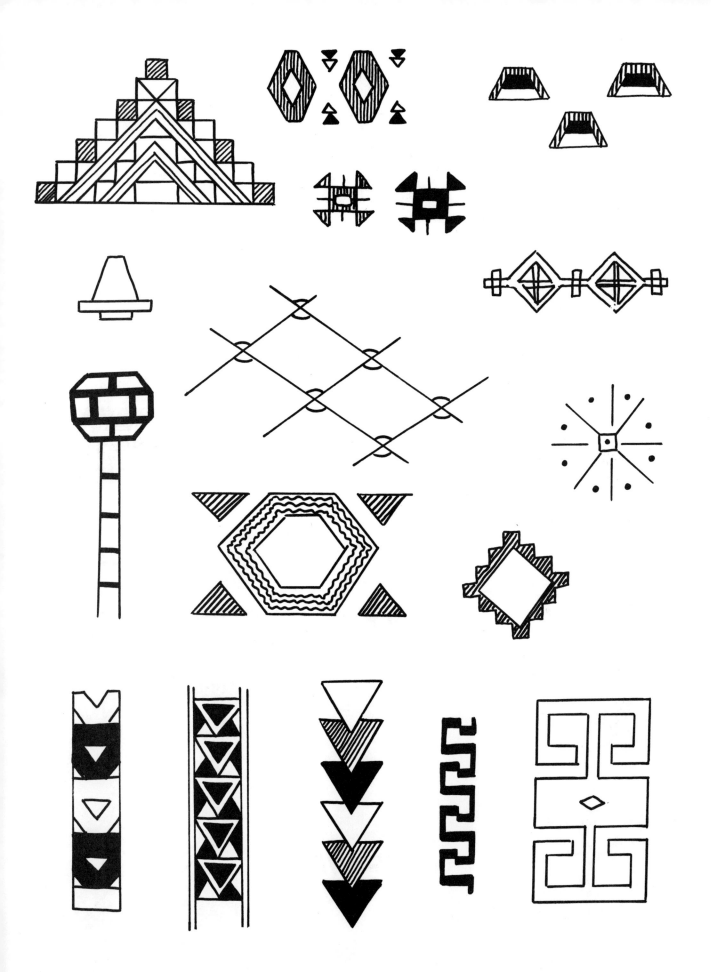

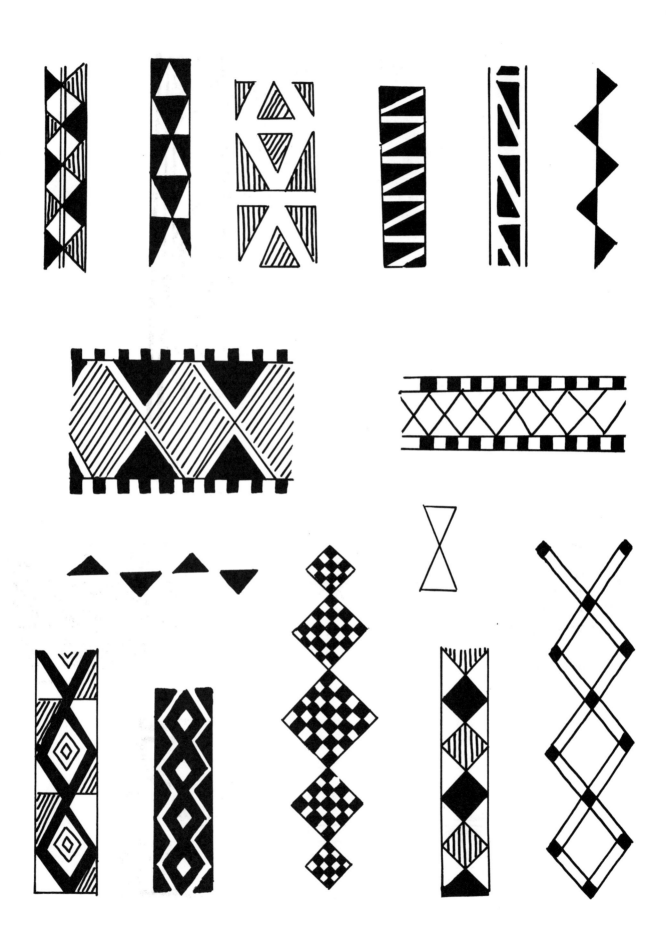

Tlingit basket designs

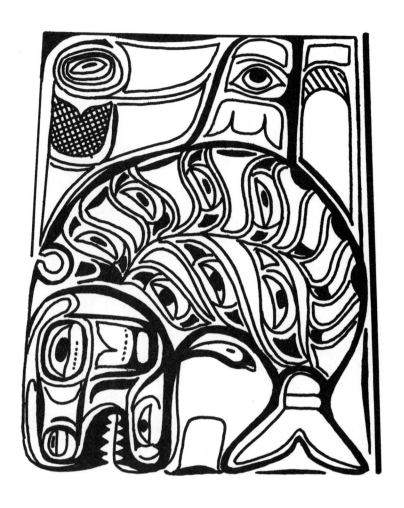

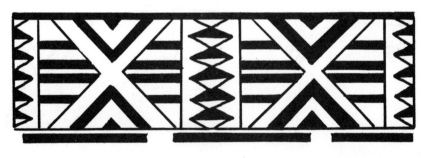

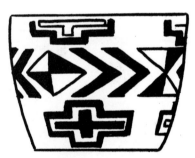

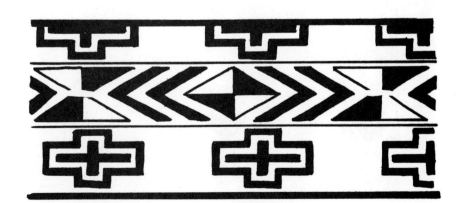

Tlingit

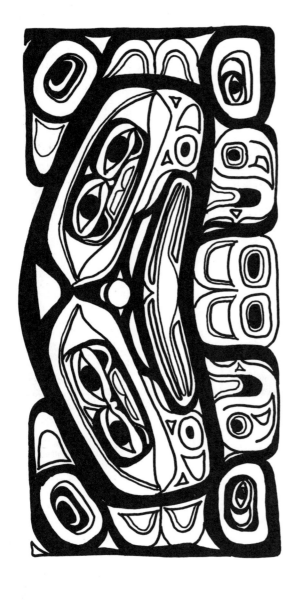

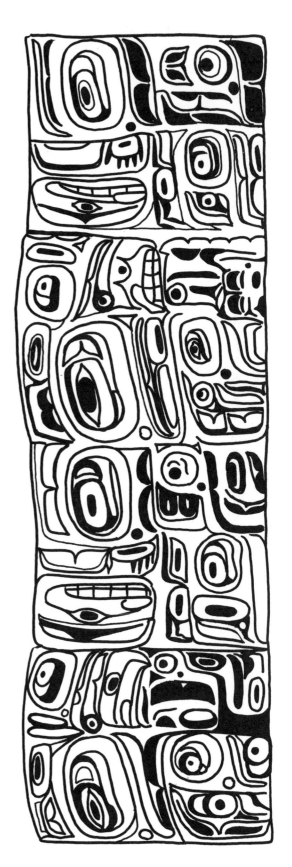

Tlingit

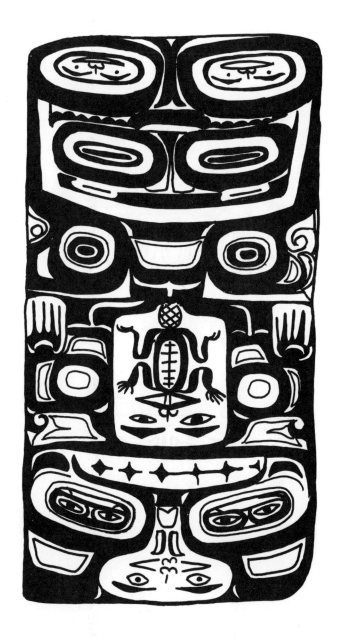

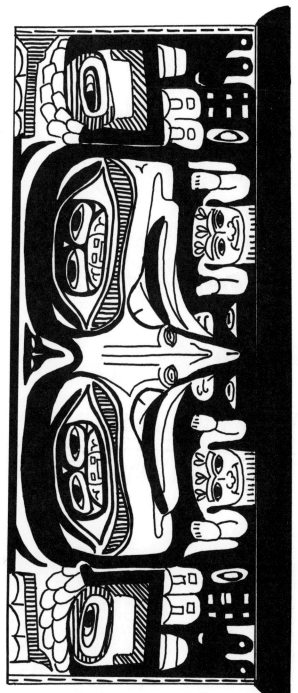

Tlingit

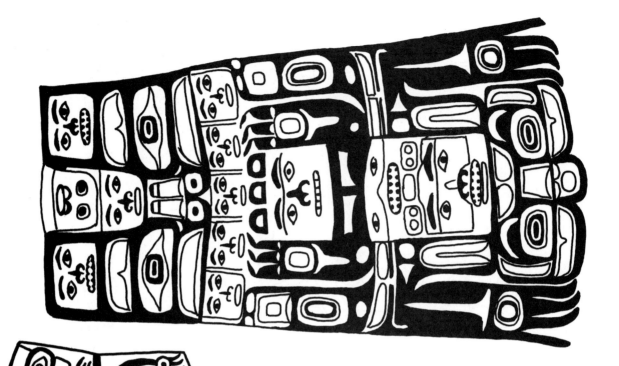

Tlingit

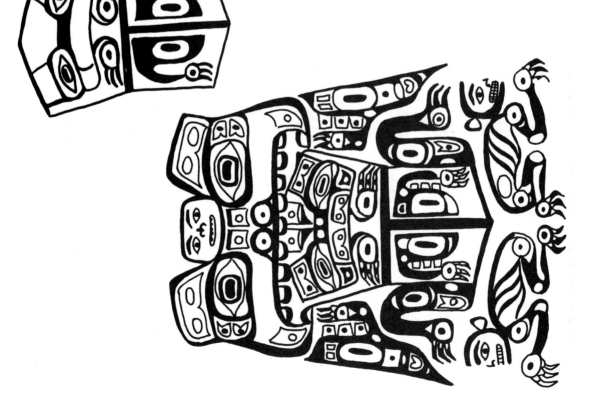

44

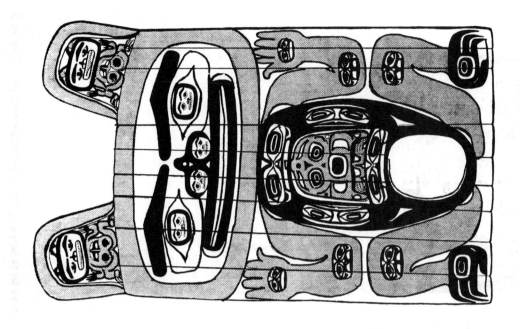

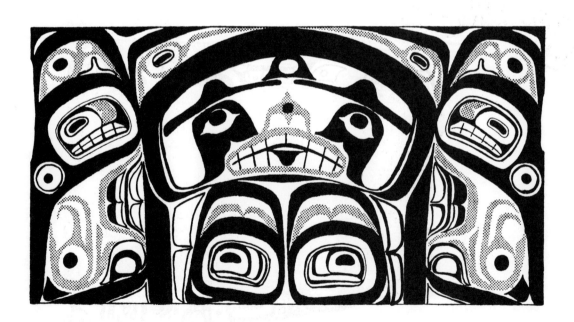

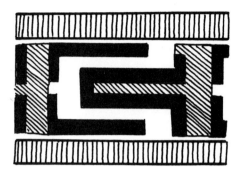

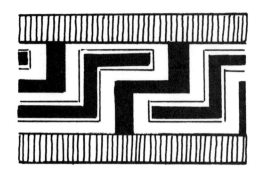

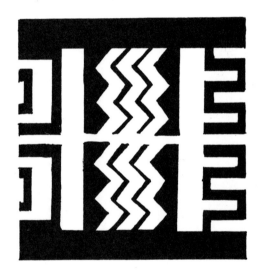

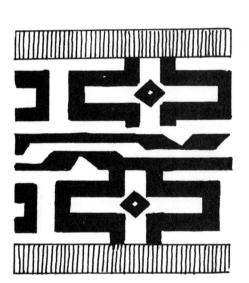

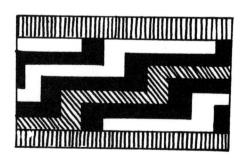

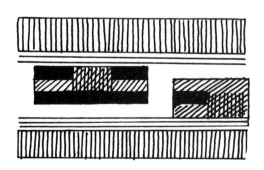

Tlingit basket designs